Flower
Mandalas At Midnight

Vol.1

A STRESS RELIEF COLORING BOOK
Black Pages

COLOR TEST PAGE

COLOR TEST PAGE

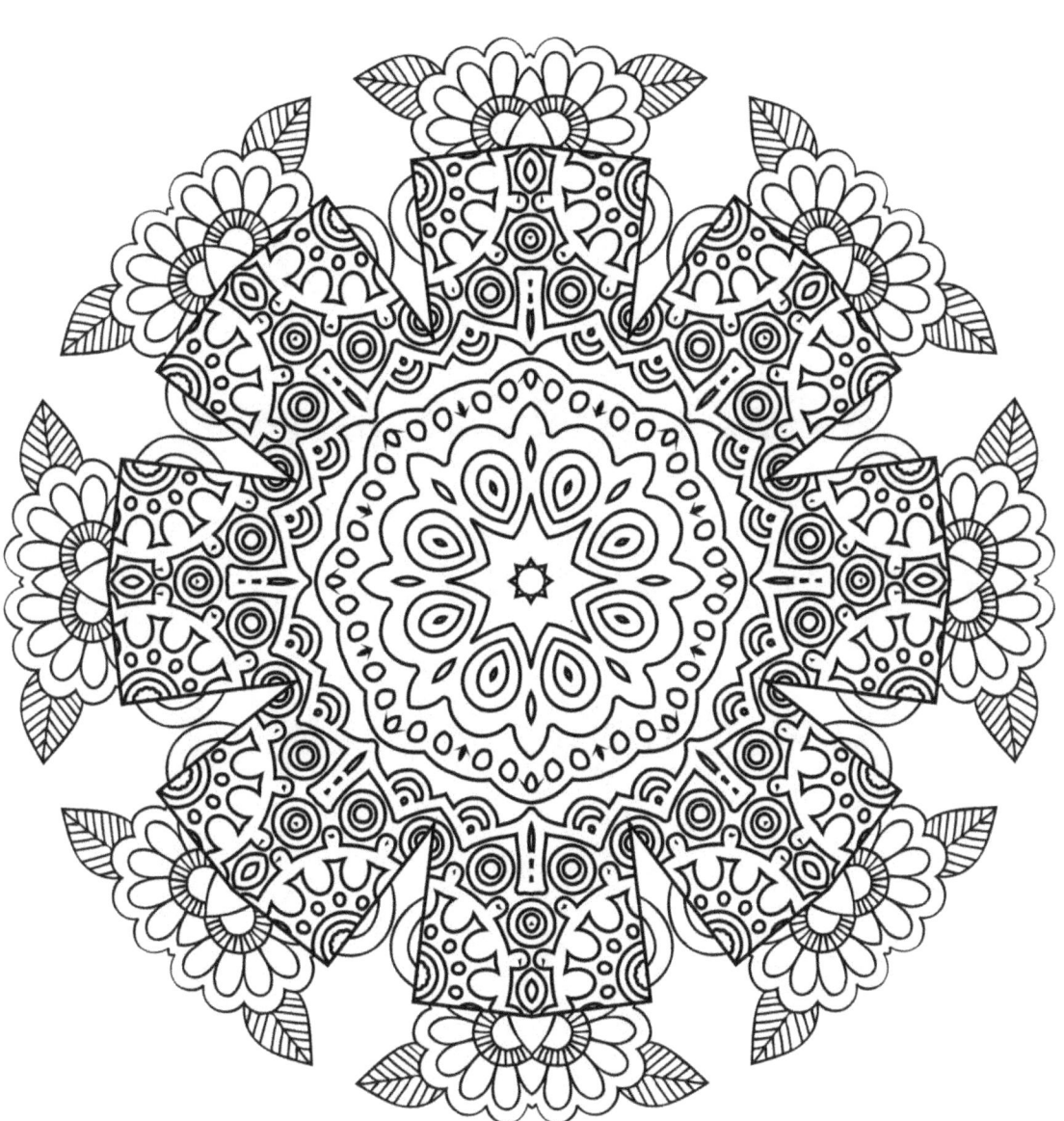

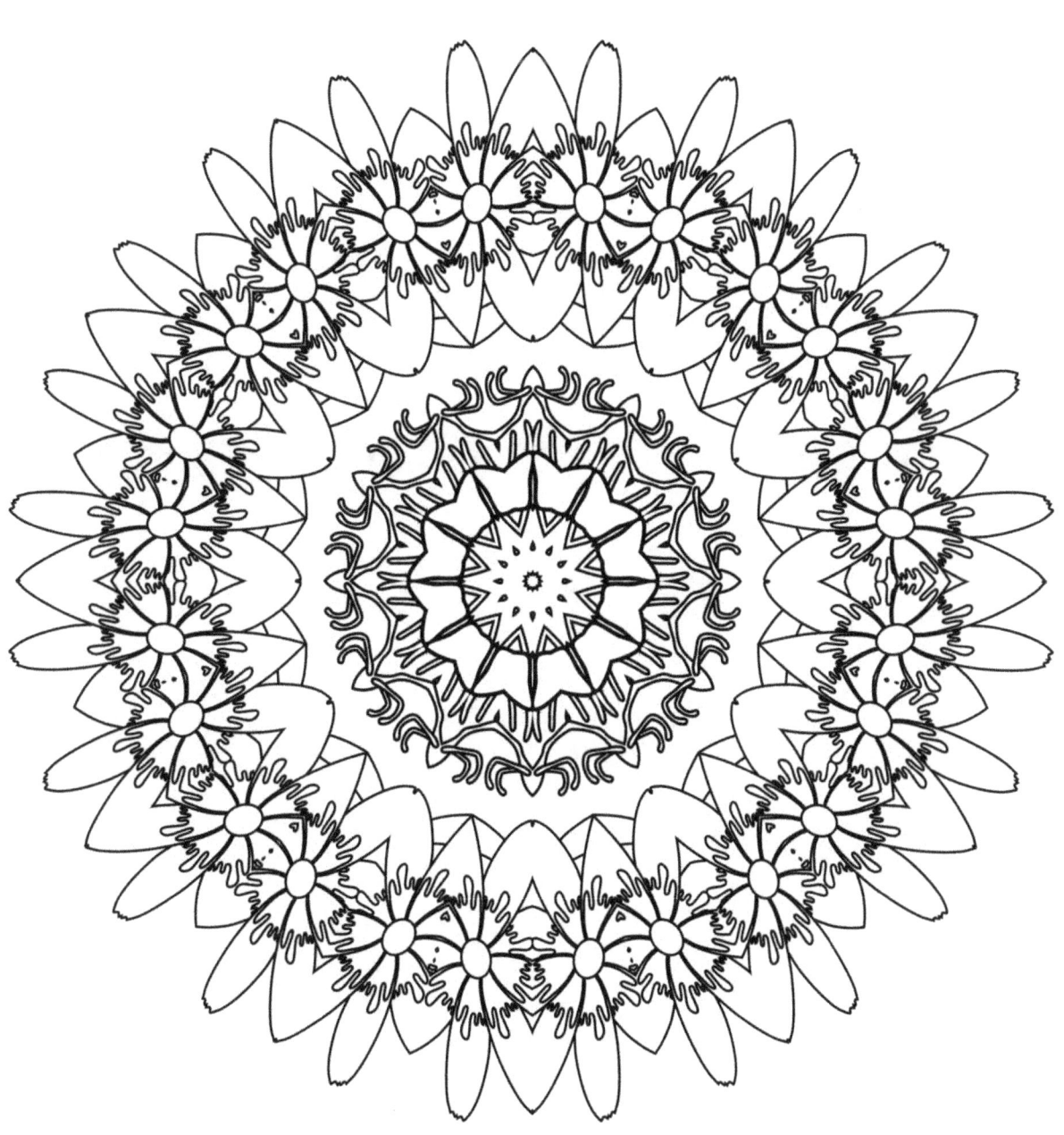

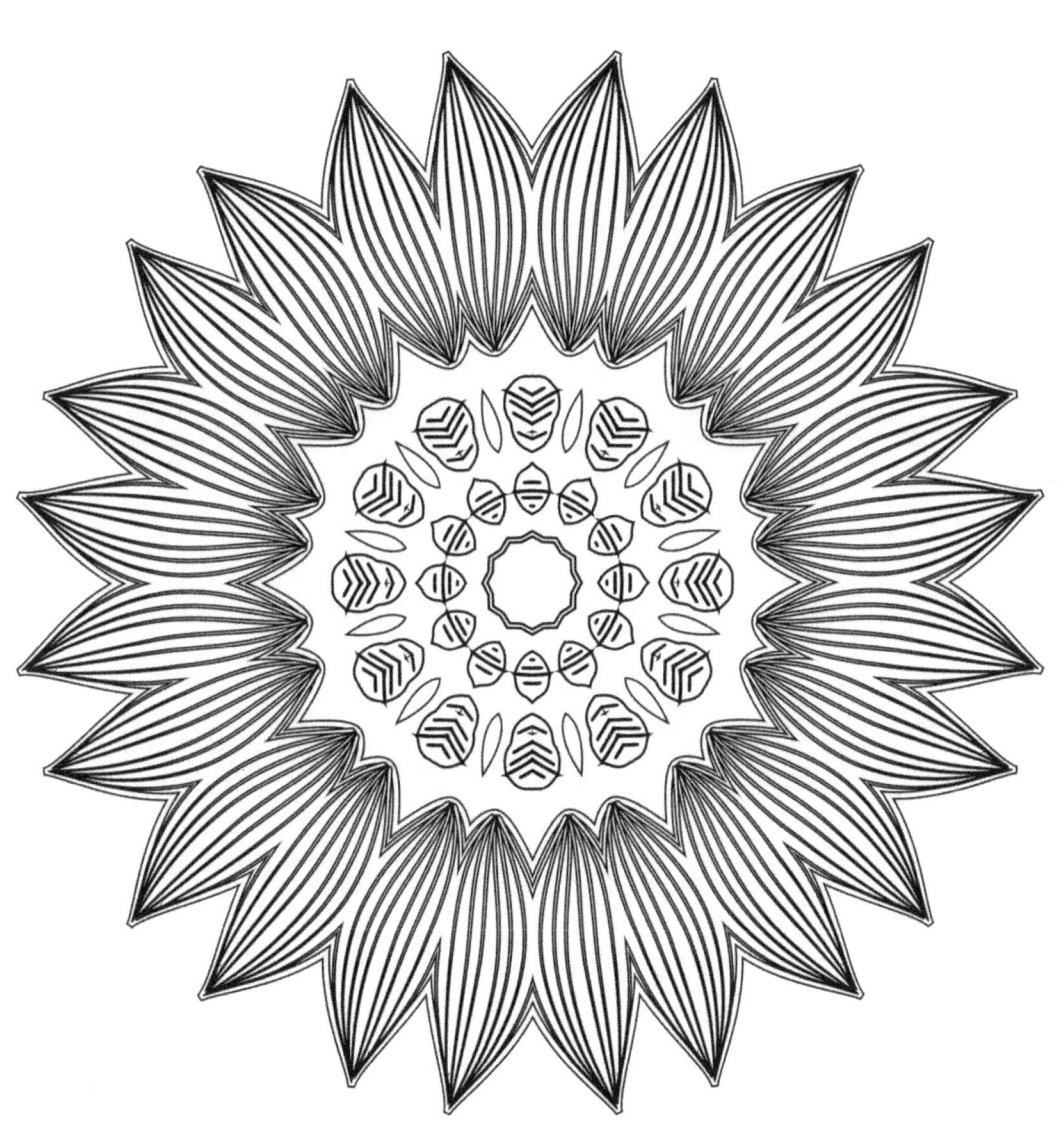

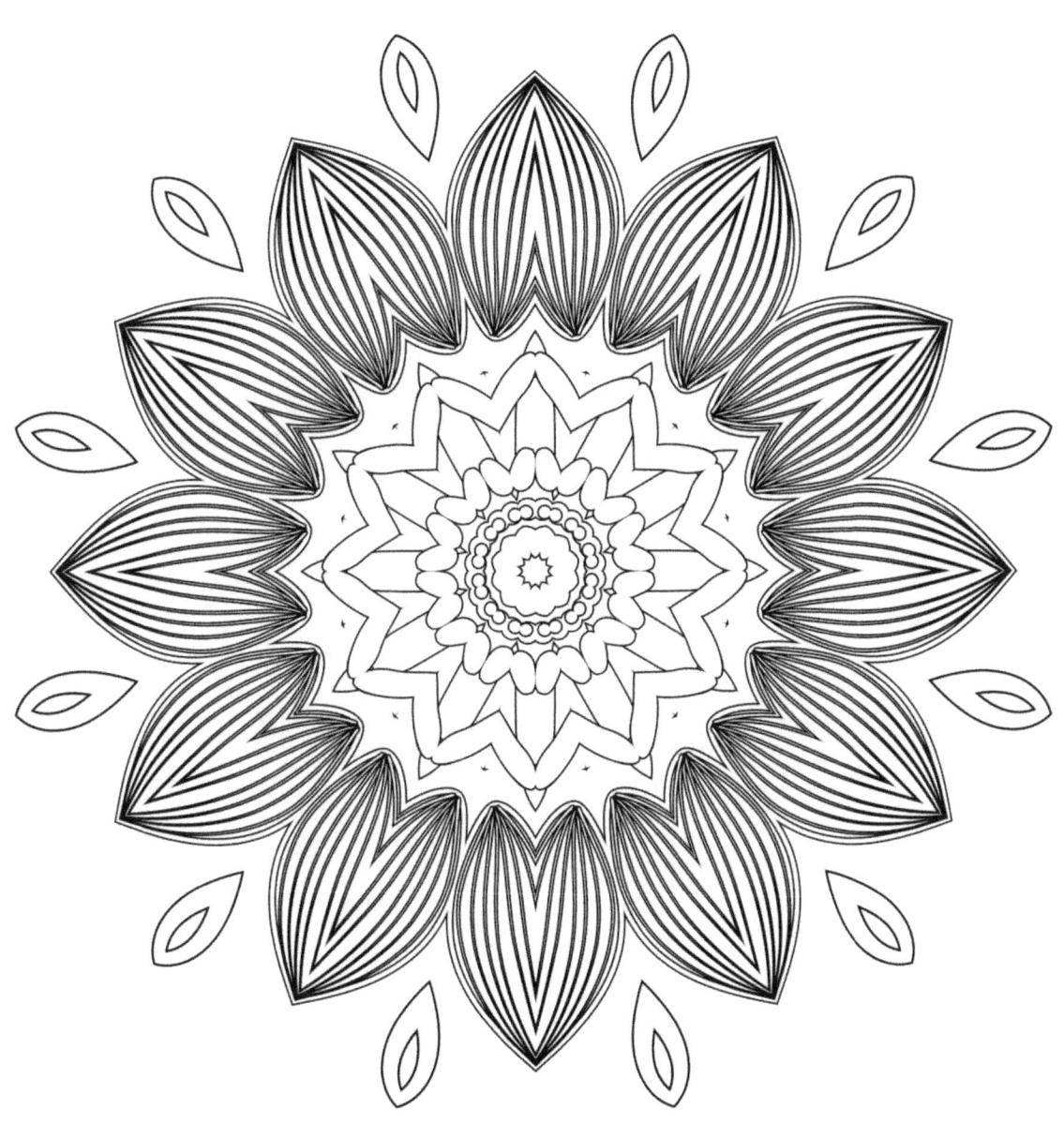

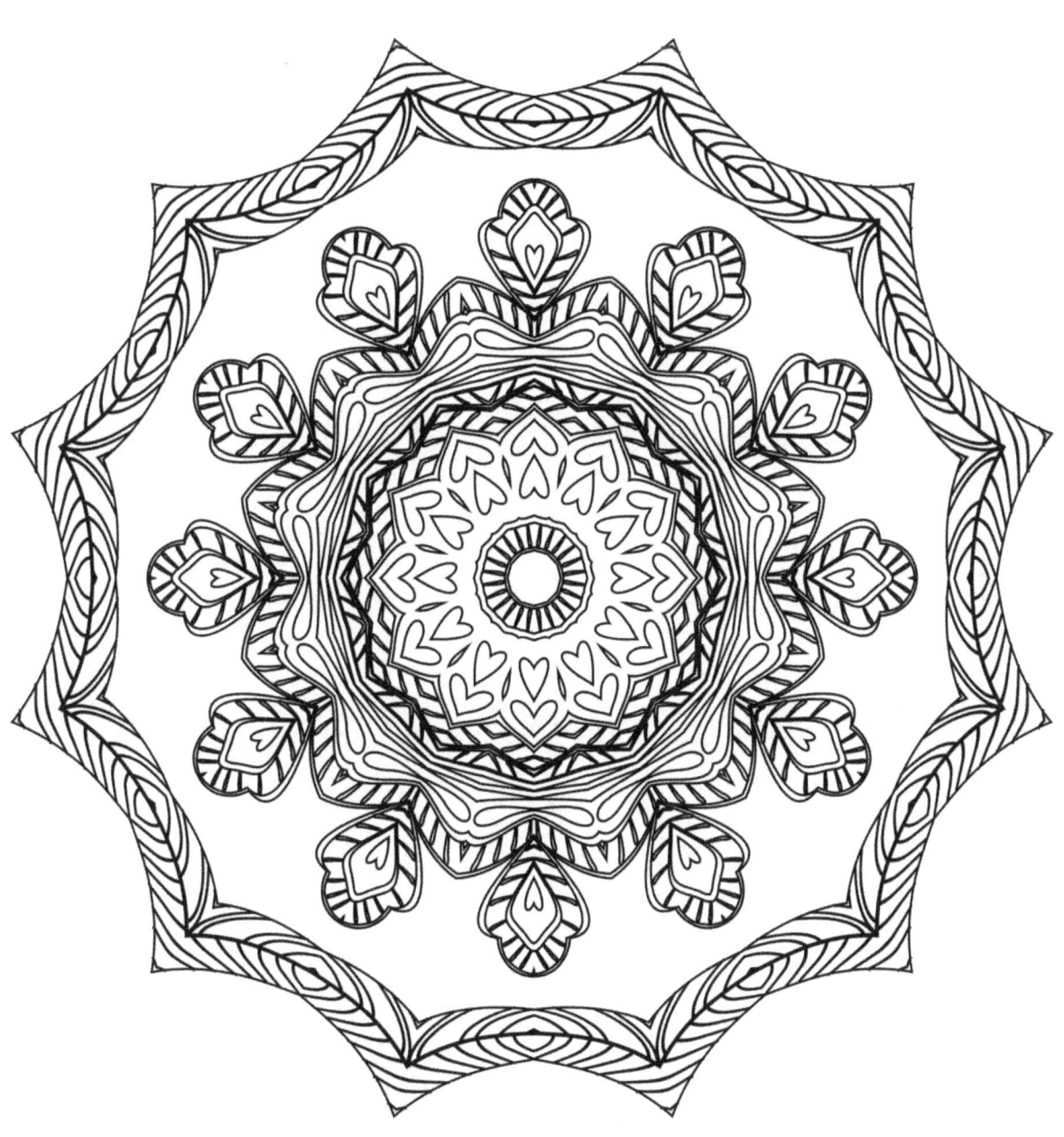

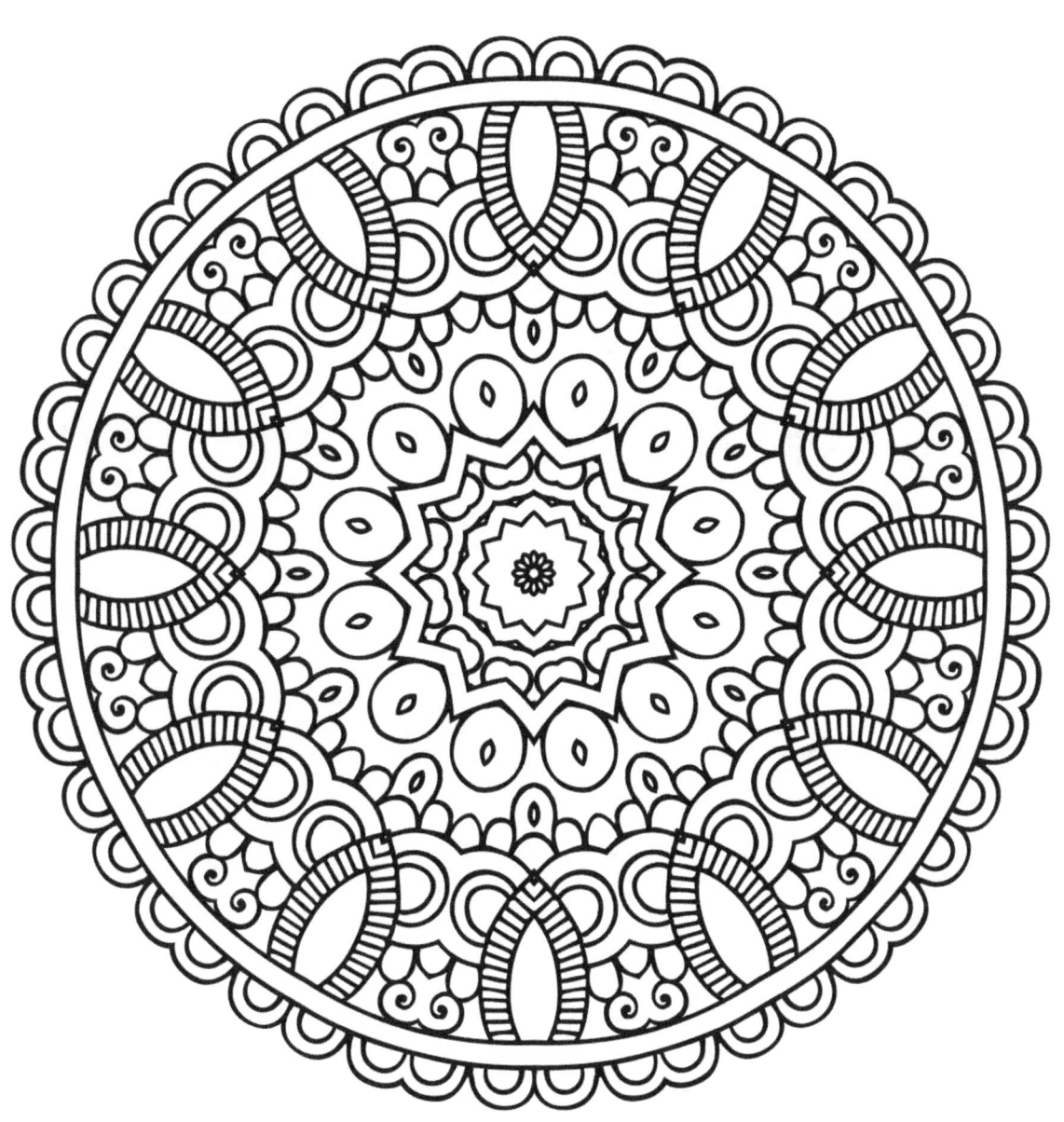

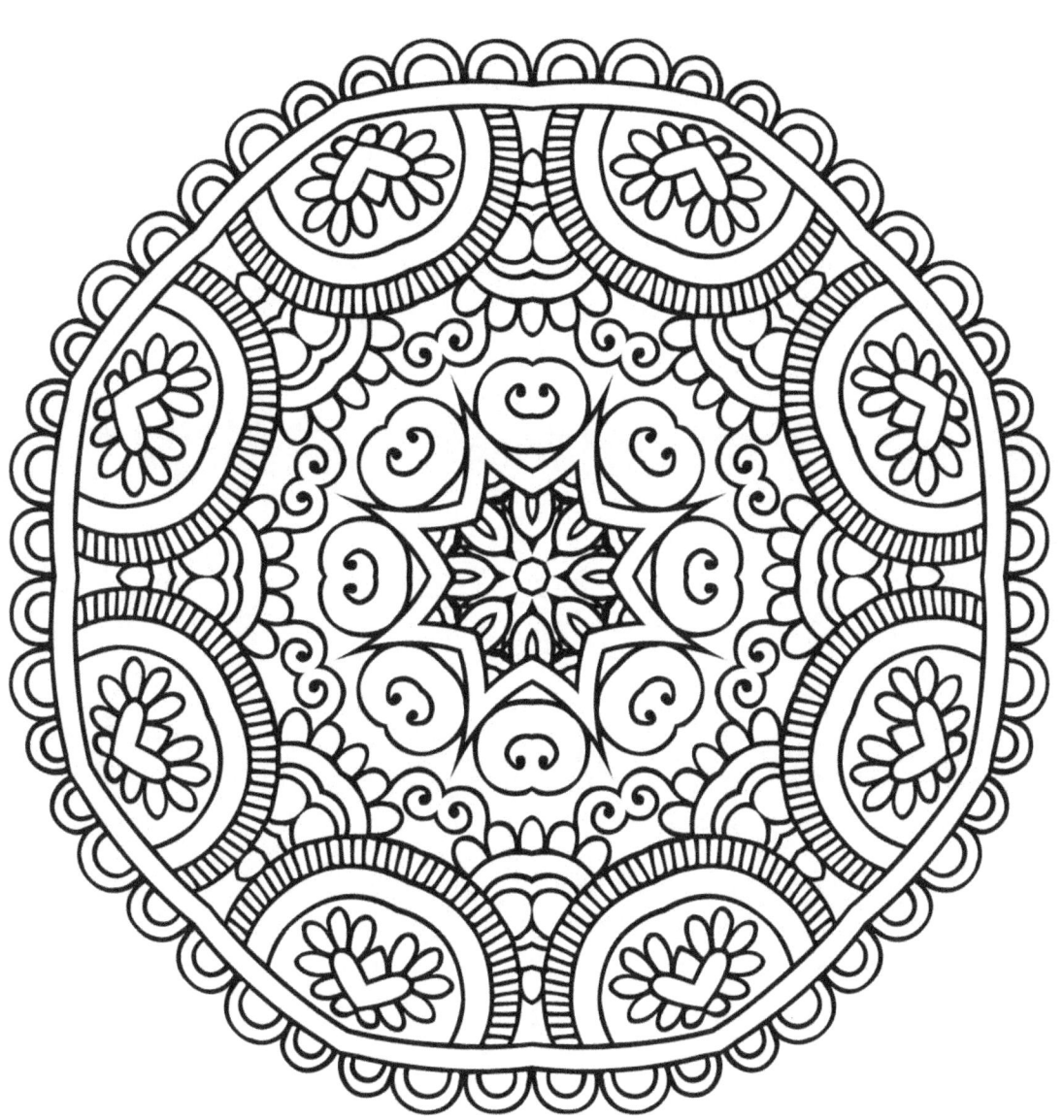

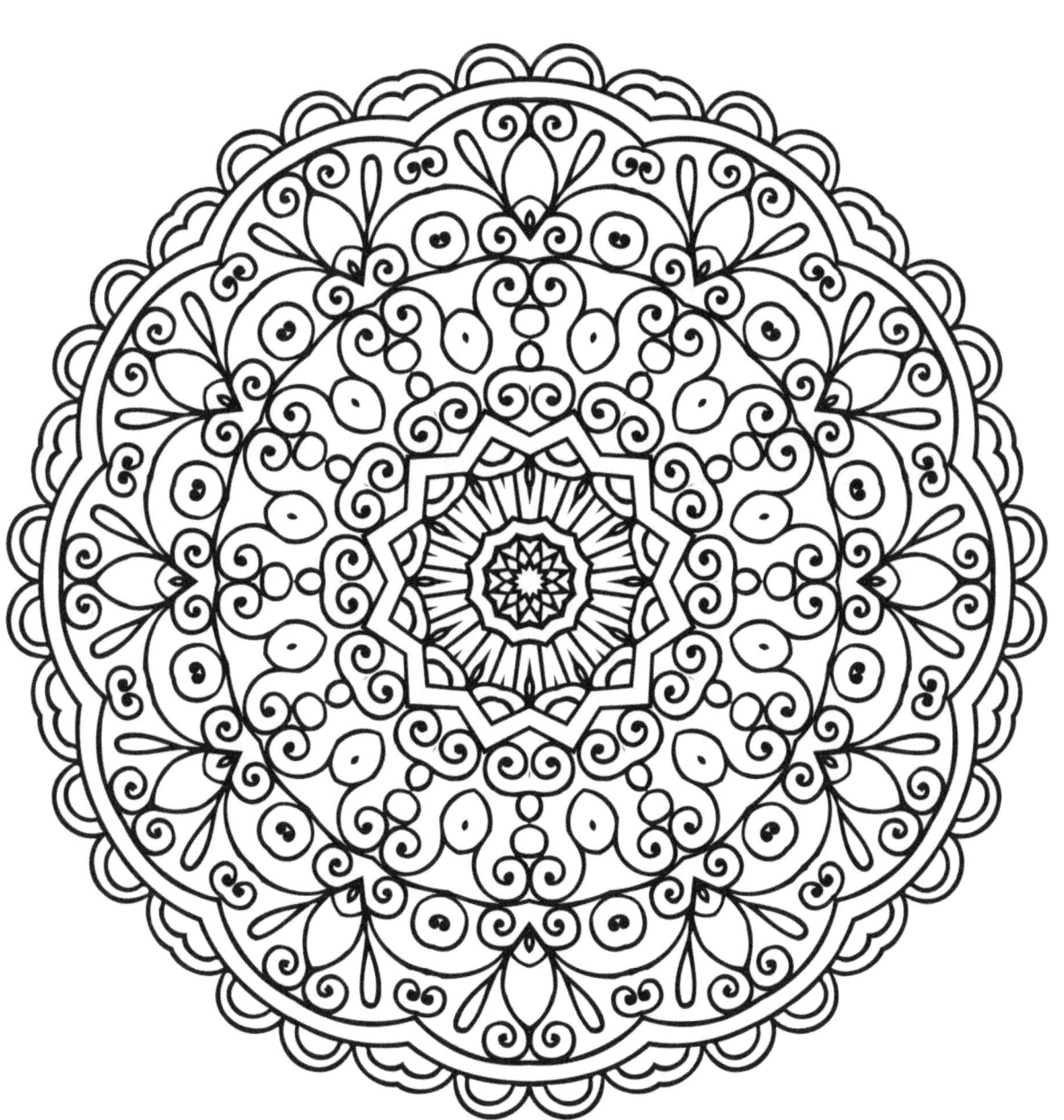

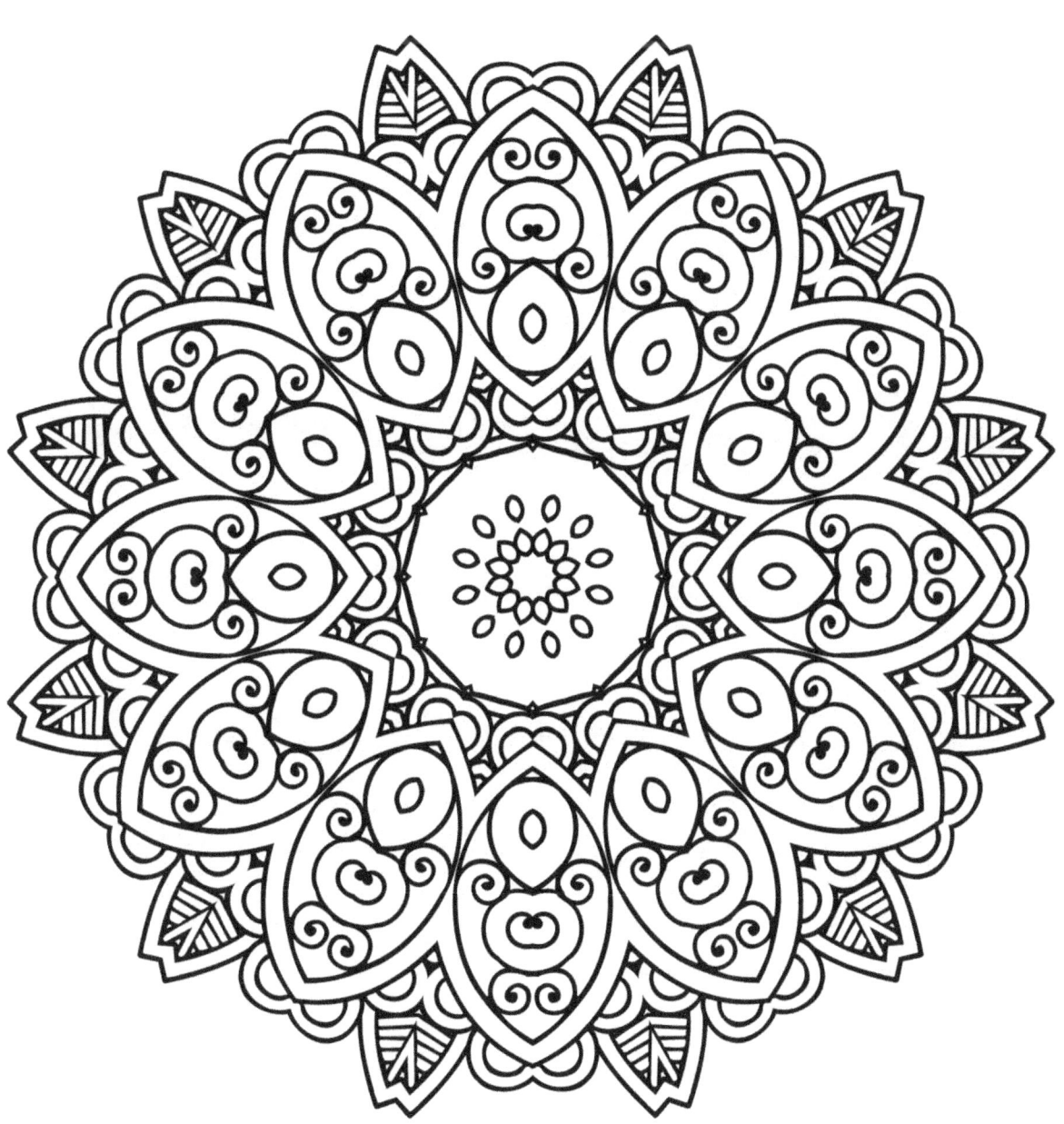

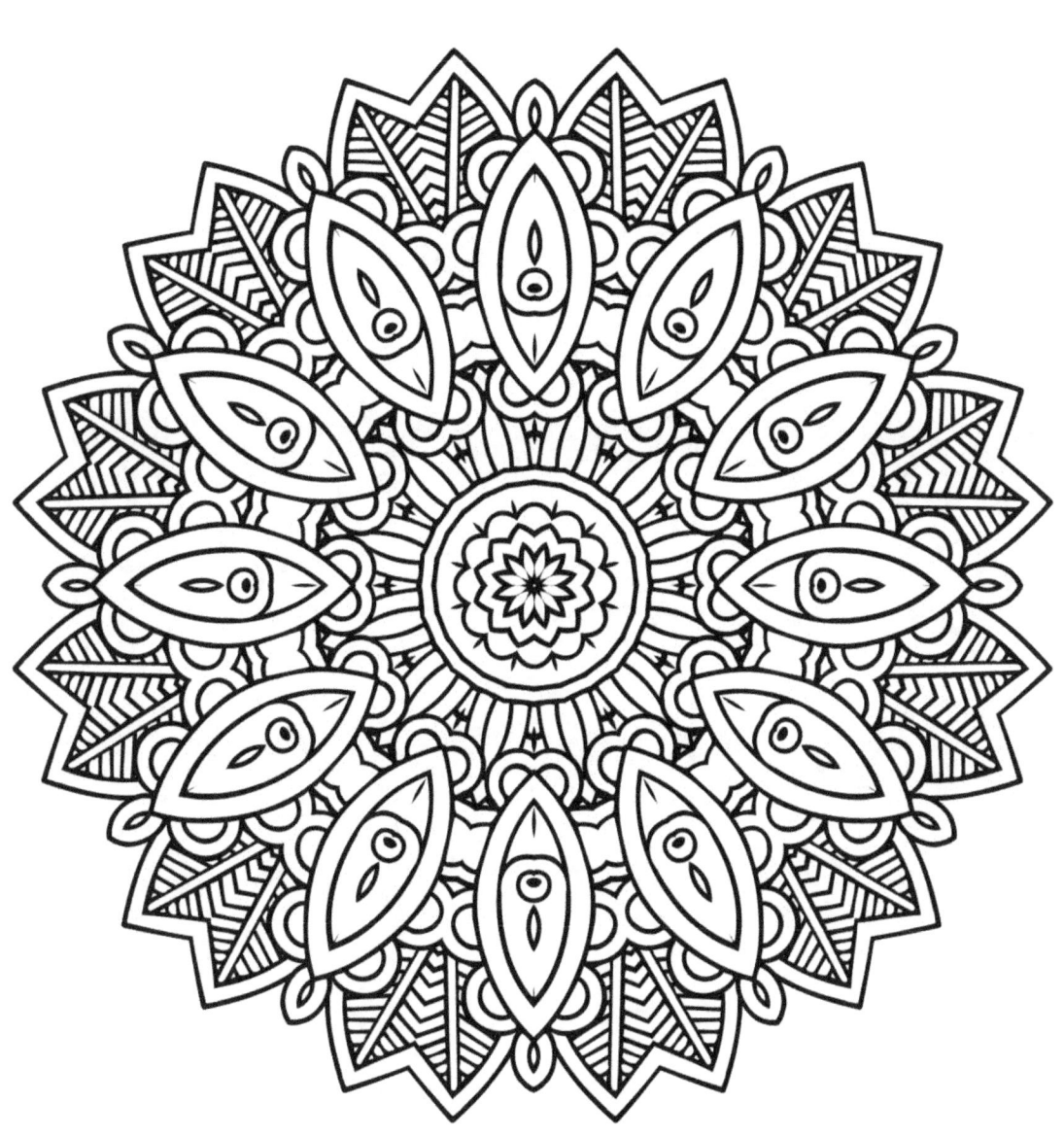

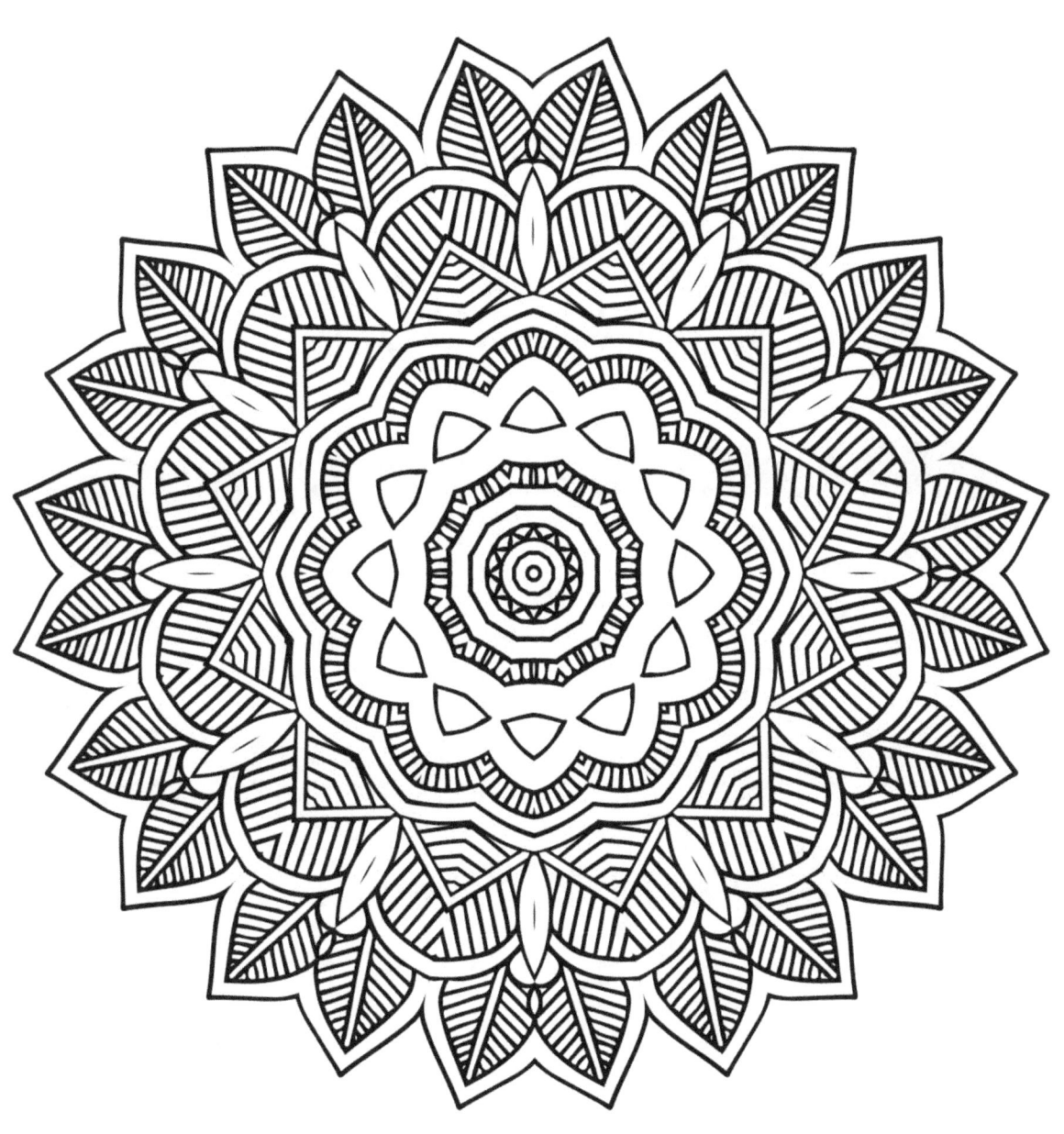

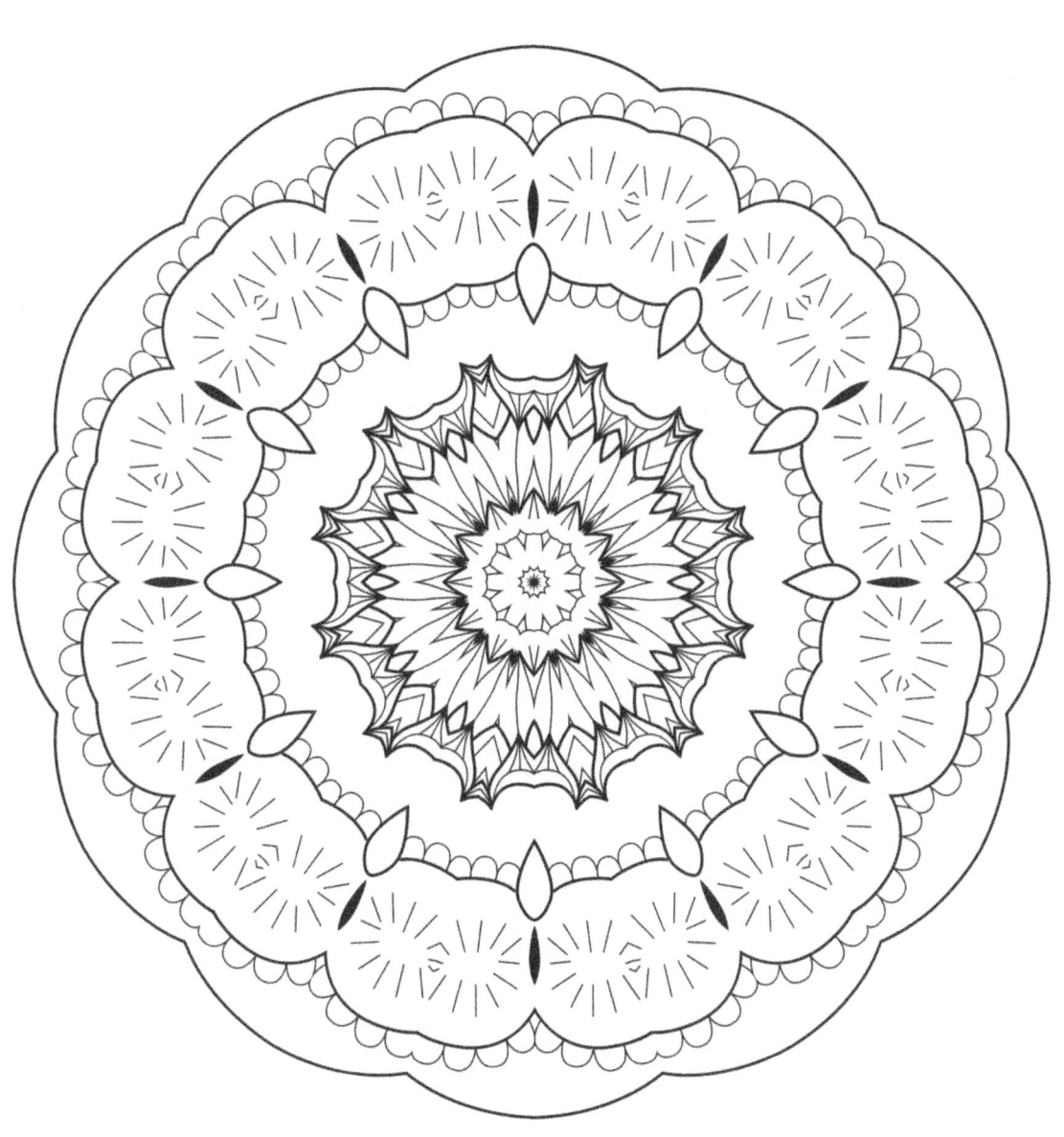

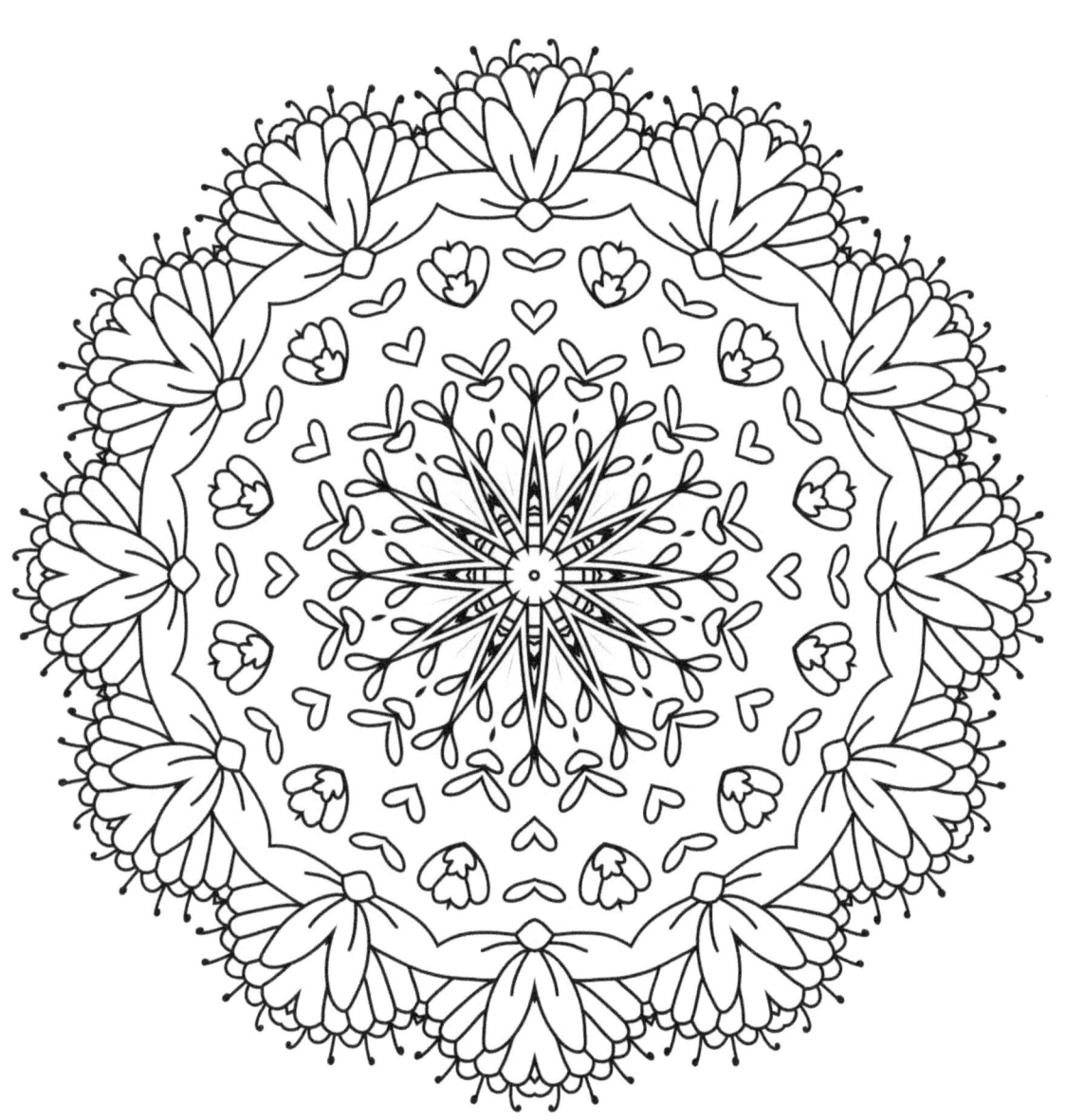

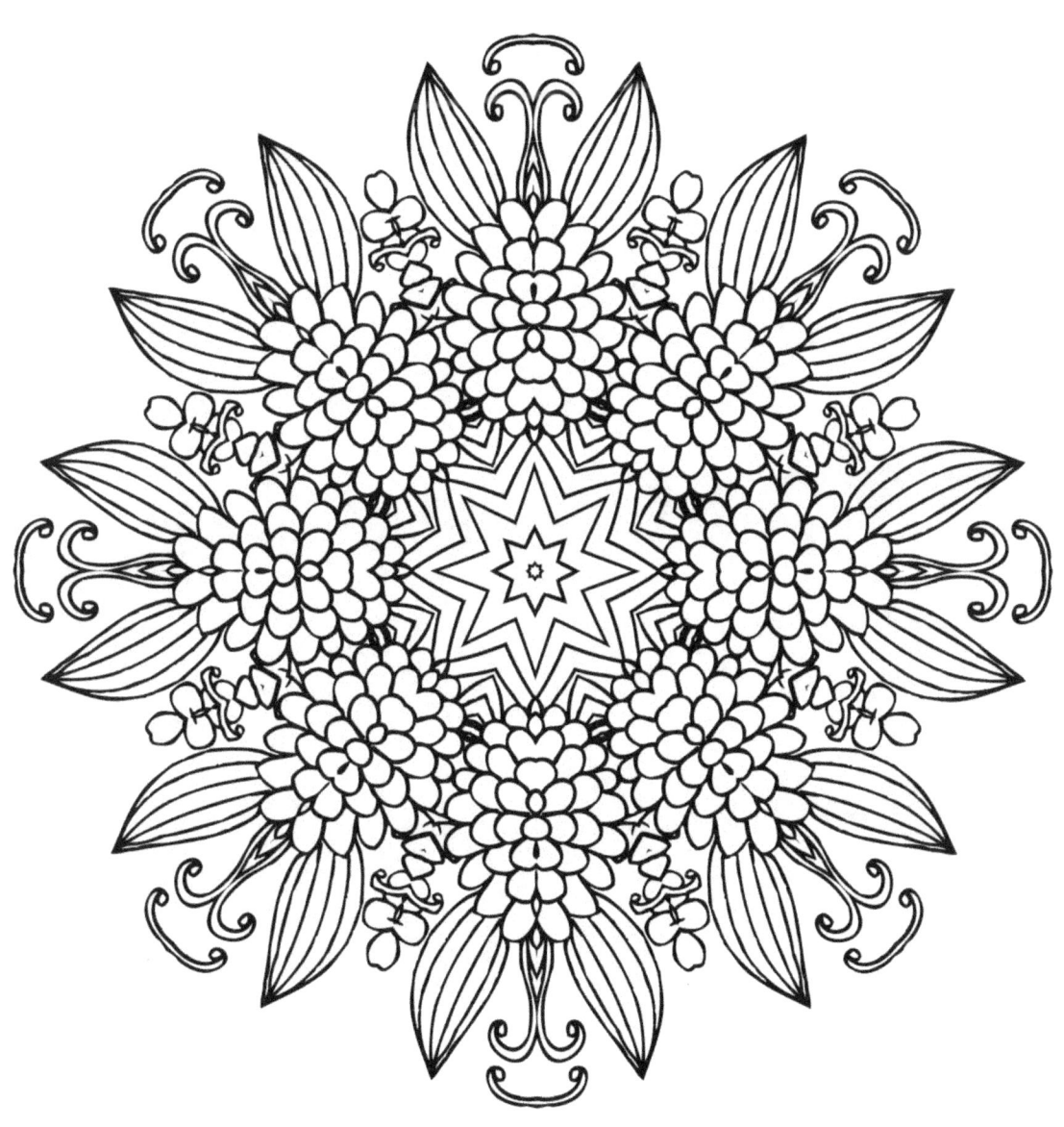

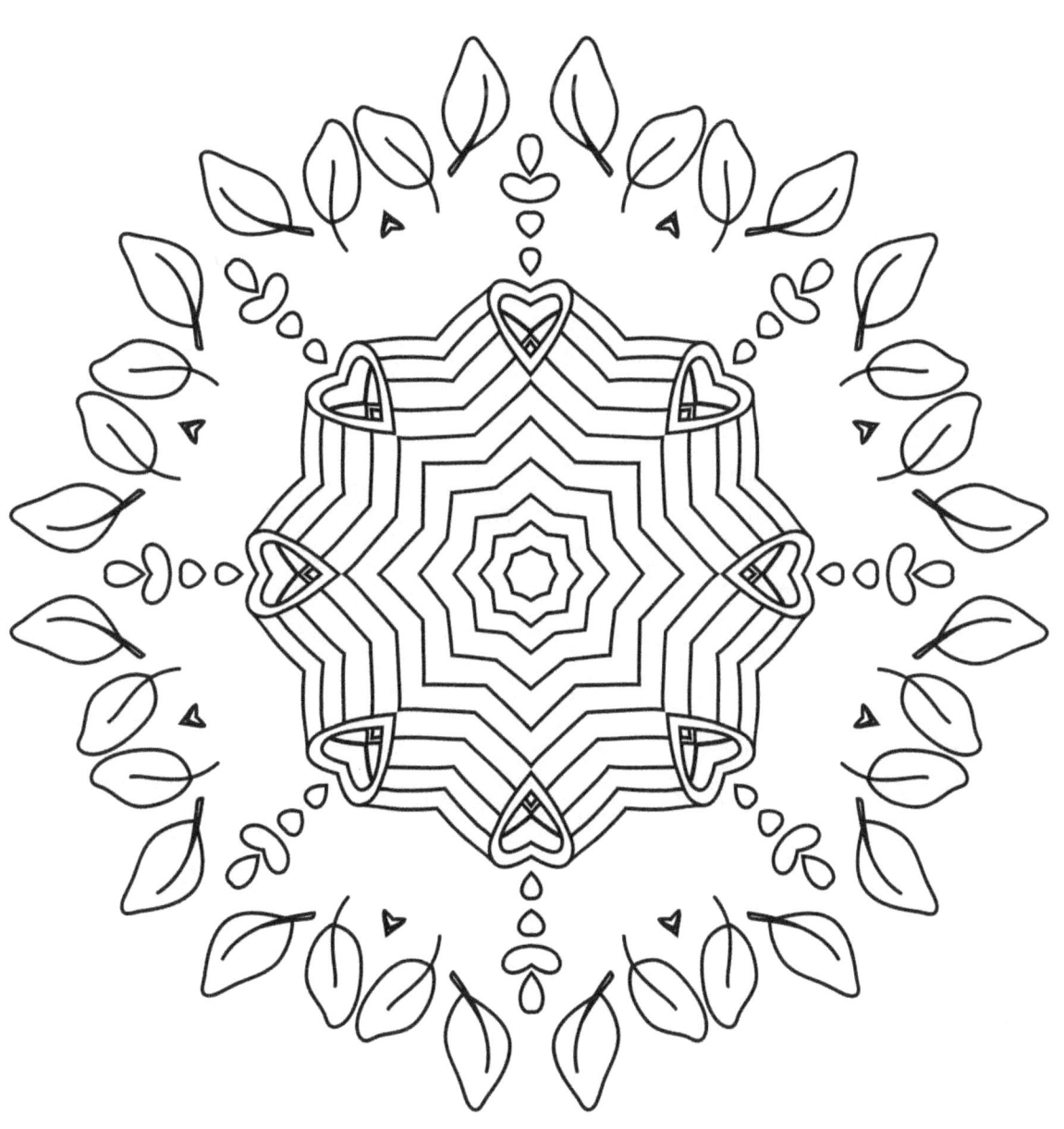

www.ingramcontent.com/pod-product-compliance
Lightning Source LLC
Chambersburg PA
CBHW080553190526
45169CB00007B/2757